Meadowlands

A Haiku Collection

By Ruth Torde

LAUREL ELITE BOOKS

Laurel Elite Books
Claremont, NH

Meadowlands: A Haiku Collection
Copyright © 2021 by Ruth Torde.

Laurel Elite Books
1 Foster Place
Claremont, NH 03743

www.LaurelEliteBooks.com

Additional copies of this book may be purchased at:
www.LaurelElite.com
Meadowlands/Ruth Torde — 1st ed.

Paperback ISBN 978-1-7360587-0-1

Book cover and interior layout: YellowStudios LLC
Cover photo credit: Ruth Torde

Printed in the USA

*I dedicate this book of haiku to
my husband, Richard.
Thanks for saving me
from an ill-formed line or two!*

Introduction

When faced with self-isolation during the 2020 pandemic, I started walking and photographing the meadowlands in my little corner of the world. Composing haiku seemed like a logical next step in my search for solace. I never before thought about writing poetry, but it surely improved my outlook on life. I hope you enjoy my simple syllables.

Melodious Meadow

Wander meadow paths,
Buttercups sing at sunset,
Melodies of gold.

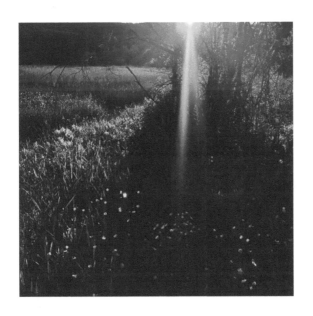

Clouds

Blue gray silken swirls
Morph to pinkish orange waves
Set the sky afire.

To the Full Moon

Daylilies love sun.
They bloom all day. Full Moon, please,
Do they bloom for you?

Walk the Labyrinth

Walk the Labyrinth.
Feel the path, the way ahead,
Pure contemplation.

Living in the North

Walk, breathe, cherish peace
In green woods. Fortunate few,
Living in the north.

Meadow Spa

Why visit a spa?
Spritz of rain, a bit of mud,
Bird songs, all for free!

Angel Cloud

Over the house, floats
A cloud Angel, arms outstretched,
Protecting our world.

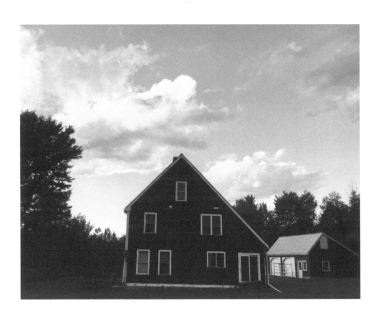

Early Fall Colors

Fall sneaks up with leaves
Popping yellow and orange.
Sunflowers just nod.

Spirit of the Wood

Spirit of the woods
I see you in the shadows
And the light of day.

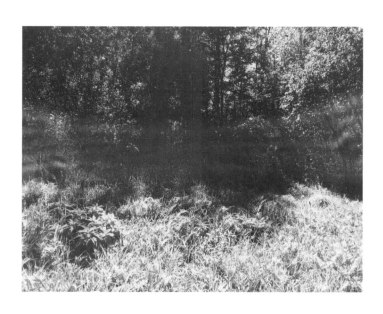

The Twilight Zone

Come wander with me
Amidst the light and shadows
Surreal and scary.

Be a Millionaire Day

Be a millionaire,
Not filled with cash, but with life,
Flowers, weeds, and joy.

Maritime Day

Sea, sky, wind, and stars
And a Brig or Schooner true
Launch my hope and dreams.

Evening Light

As the sun goes down,
It leaves a pure, fleeting light
To kiss the meadow.

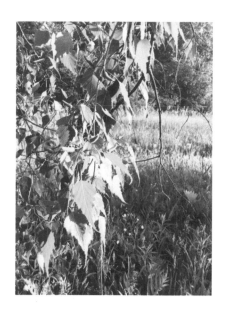

Magic Sunset

Sunset casts magic
Over buttercups and fern.
They sparkle and dance.

Summer Rain

Good day, rainy day.
Leaves flutter and skies are grey.
Snooze time for the sun.

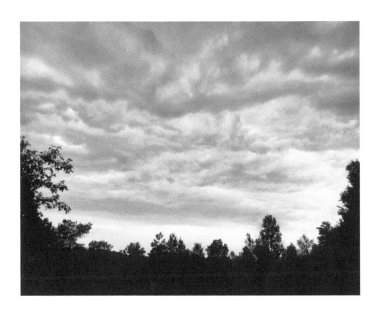

Walking in the Rain

Light rain, light hearted,
Roam the meadow, search for stones.
Bliss found all around.

Magical Meadow

Take the magic path
Through the blooms and butterflies
To the meadow's peace.

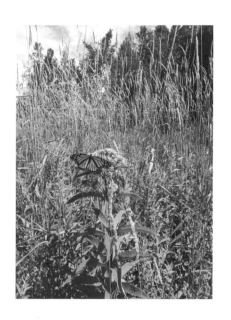

Clouds After Rain

Rain pours and passes.
Clouds fearlessly crowd the sky.
Makes me gasp with joy.

Butterflies

Butterflies flutter,
Peaceful monarchs of their realms,
Tranquil and so free.

Breeze

The breeze is gentle.
Leaves dance, birds sing. Not a care
In the world, just now.

Elves

Gaze through leafy boughs
And, dazed by the misty sun,
Behold twirling elves.

Green Mornings

Chartreuse, lime, spring green
Touch forest, sage, teal, and Jade.
A carefree medley.

Nature's Helping Hand

Vines brace Branch.
Branches back Weed in full bloom.
Big leaves shade the Young.

Nature's Helping Hand

Vines brace Branch.
Branches back Weed in full bloom.
Big leaves shade the Young.

Sunlight

Well known paths gleam bright.
Sunlight touches leaf and vine,
Bestowing stardom.

The Next Adventure

What prize lies beyond?
Leafy boughs shield the portal
To sheer adventure.

For Monday

Sunny Monday's here.
Maybe rainy later on.
Don't get down, get up!

Seasons Change

Seasons change slowly,
Trillium, day lily, rose
Move on for the next.

Brilliant Light

The light so brilliant
That blooms rejoice, vibrating
Purple, gold, and green.

Joy

Joy is peaceful rest,
Then walking the green meadow,
Saluting the day.

Cool Day Colors

Cool day, colors shine.
Hints of Fall excite the soul.
But, Hold on, Summer!

Car Wash

I can see clearly
As blue green suds rinse away.
What a rainbow day!

Sunset

Suddenly, the sky
Is pink. Run outside, chasing
The bold, fleeting sun.

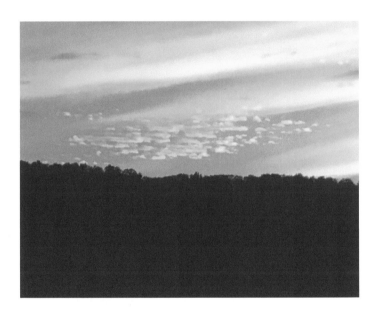

Fickle Nature

Quick! Nature's fickle,
Her sun awakens a leaf,
Then withers with frost.

Flowers in their Beds

Flowers in their beds
Need rain and sun. They flourish
With our love and care.

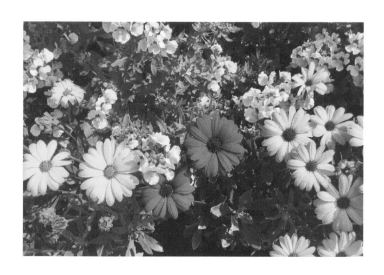

What's in a Name?

I say wildflowers,
You say weeds. But, let's agree
To bask in beauty.

Our Little Corner of the World

This little corner
Of the world is fine with me,
Surrounded by love.

Autumn Cathedral

Cathedral of leaves
Stained orange, swaying with hymns
Of hope, joy, and praise.

Changing Leaves

Green, golden, soon brown.
Leaves change, bursting with color,
Then dwindling to sleep.

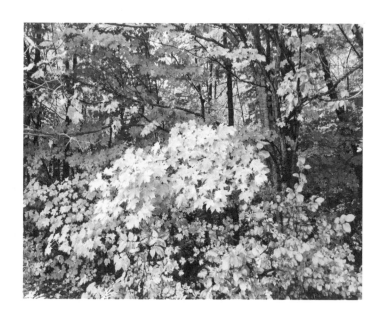

Haiku on Rustling Leaves

Leaves fall. Bare branches
Look stark. Underfoot, find joy
In crisp, rustling leaves.